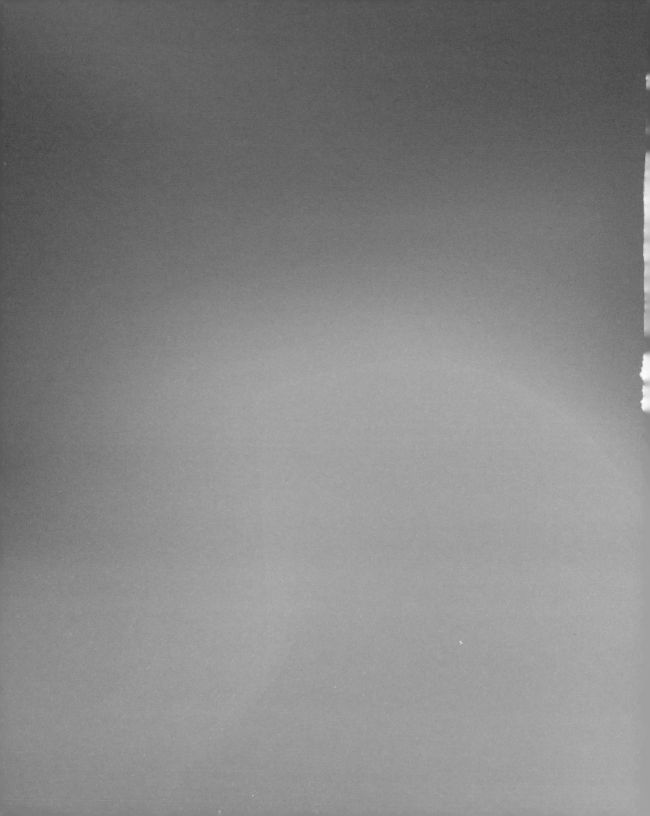

WHAT CAN
COLORS
DO?

Liz Yohlin Baill

Princeton Architectural Press · New York
Philadelphia Museum of Art

THERE'S A RAINBOW OF WAYS TO THINK ABOUT COLOR.

From primaries and patterns
to feelings and favorites,
colors are full of possibilities.

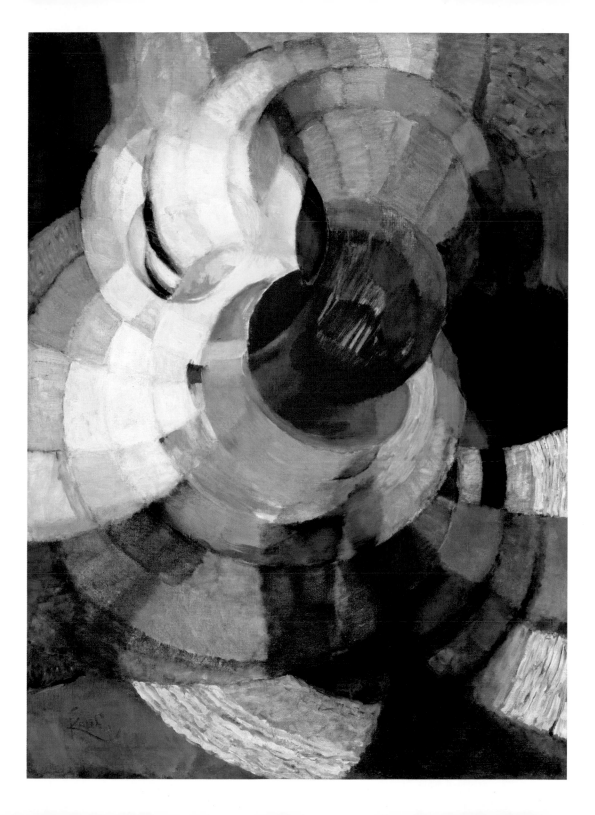

Colors can be
WARM

Sunshine, fire, lightning...
these are all hot. Yellow, orange, and red
remind us of things that feel warm.

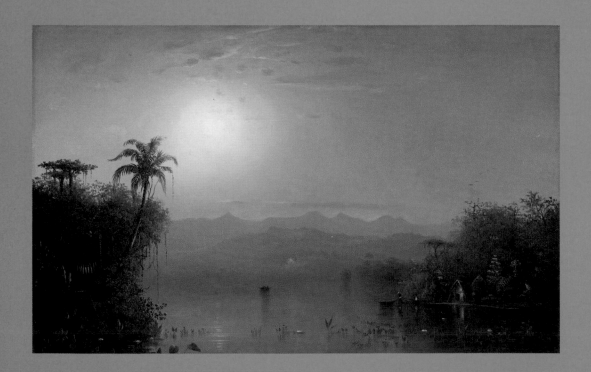

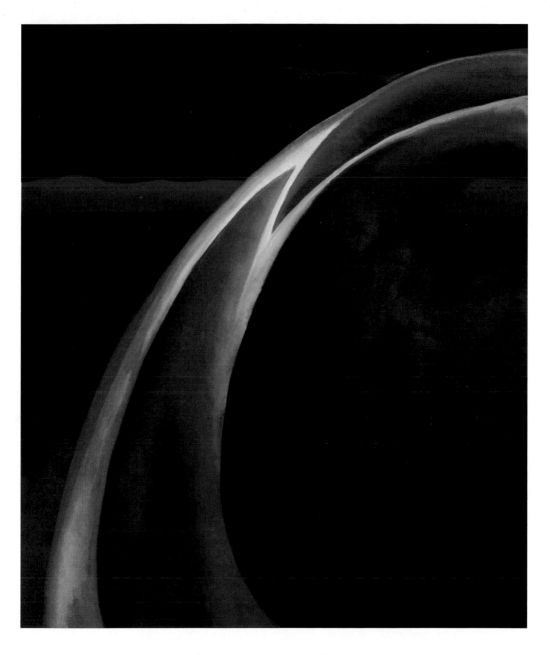

A sun sets over a lake.
A flash of light swoops through the night.
What else do you spy in each warm-colored sky?

Colors can be
COOL

Rivers, raindrops, icicles…
these are all cold. Blue, gray, and purple
are shades that make us shiver.

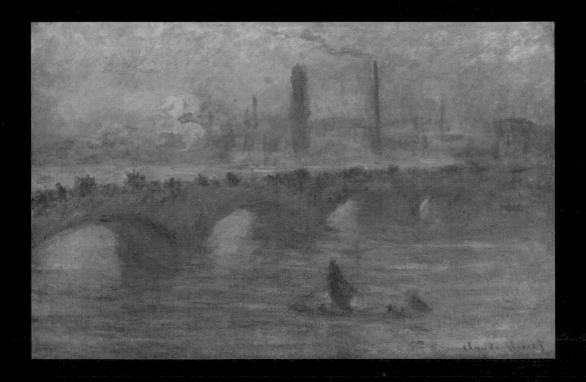

Bundle up in these cloudy landscapes.
Choose the chilliest one and imagine taking a walk.
What do you hear, smell, and see as you stroll?

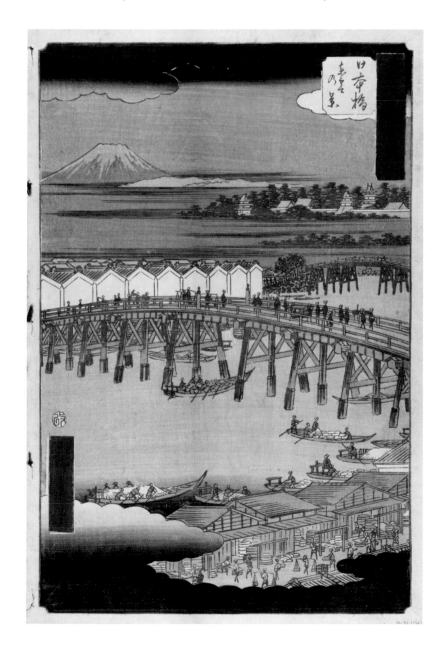

Colors can be
PRIMARY

**Red, yellow, blue—
what tricks can they do?
All other colors come from mixing
these trusty three called primary.**

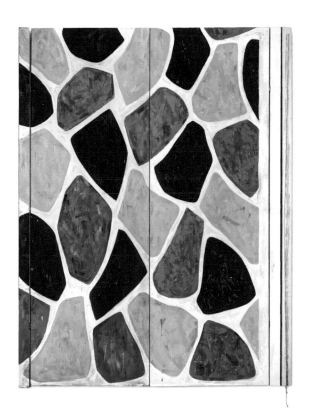

How many times does
each color appear?
Keep count and spot two
rosy fish along the way.

These painters
picked perfect primaries
for their palettes.

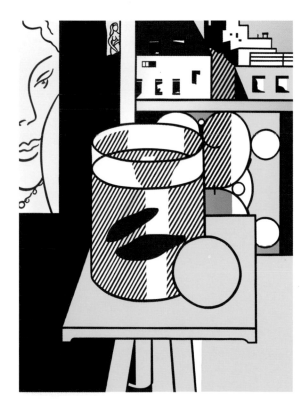

Colors can be
SECONDARY

Purple, orange, green—
here's what we mean.
Each secondary color is made
from mixing two primaries.

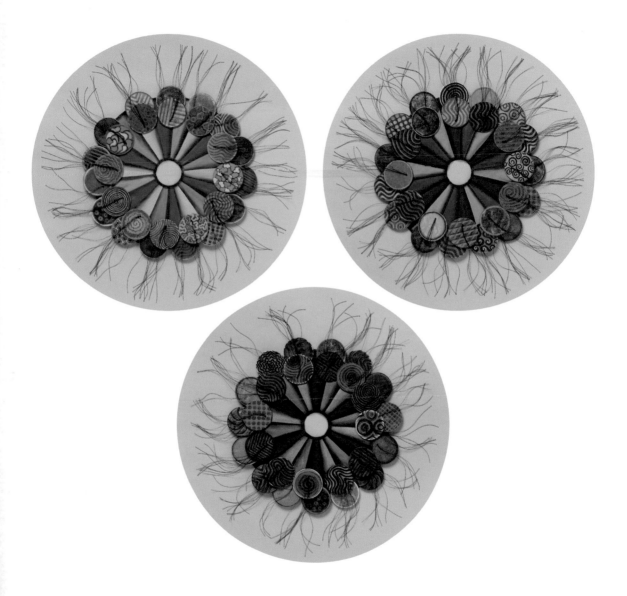

Count three circular sculptures in secondary shades.
Look for light, medium, and dark colors in each dizzying design.

Colors can
COMBINE

Some artworks let our eyes do the mixing.
How did these artists use their paints?

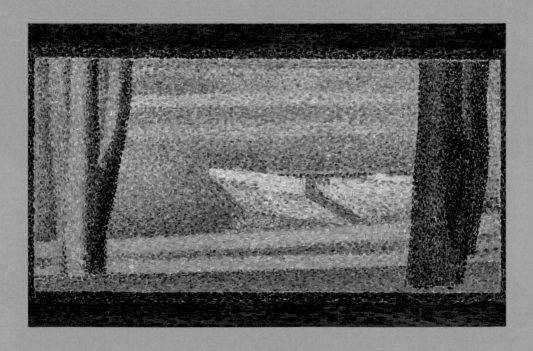

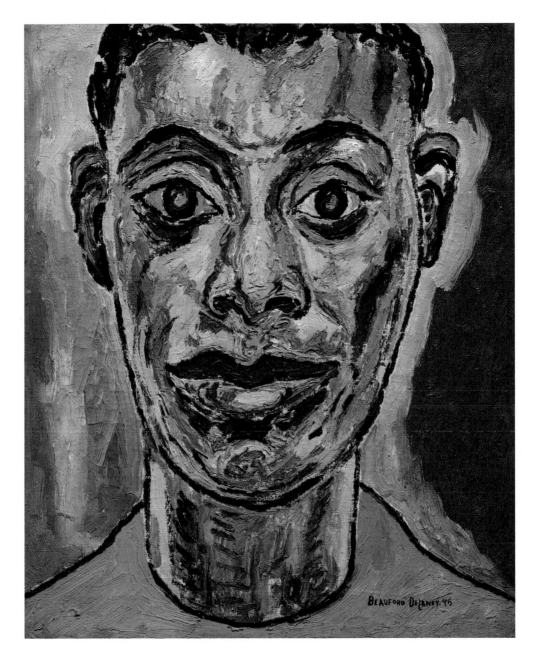

Spot lots of dots in this little landscape and bright
brushstrokes in this portrait. Our eyes blend these bits of
color to see light and shadows from afar.

Colors can

POP

**Some colors shine extra
bright when they're together.
Red proudly pops
when surrounded by green.**

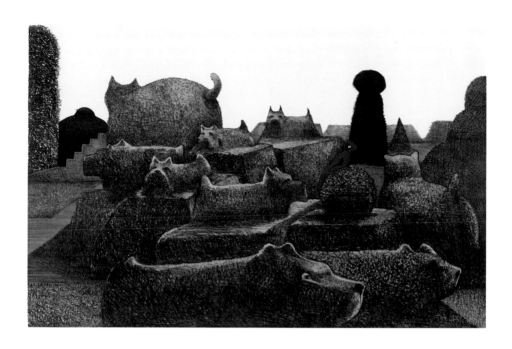

What stands out in these grassy gardens? What blends together?
Imagine stories for these poppy pictures.

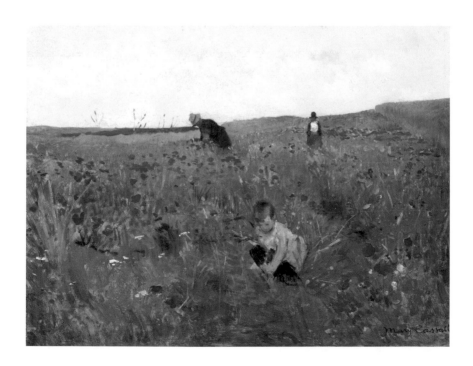

Colors can
SHINE

**Shimmery shades that look
perfectly polished are called metallic.
Colors like silver and
gold reflect light to look shiny.**

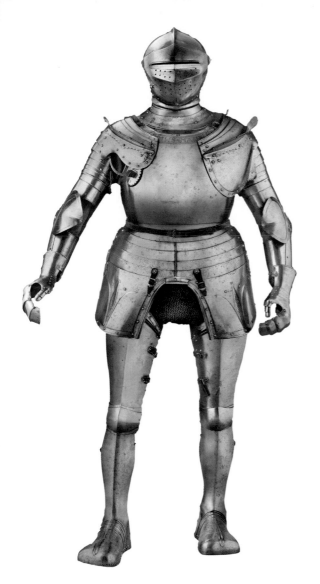

Now sit still and calm like this copper statue covered in gleaming gold.

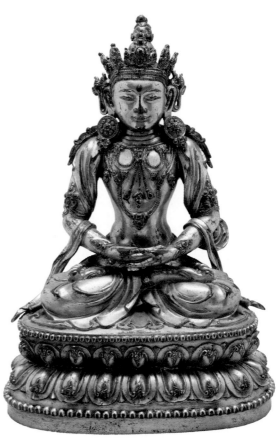

Make this metal move! Pretend to suit up in silvery steel and walk like a knight in shining armor.

Colors can
have different
SHADES

Light and bright, dim and dark,
and everything in between.
How many yellows can you count?

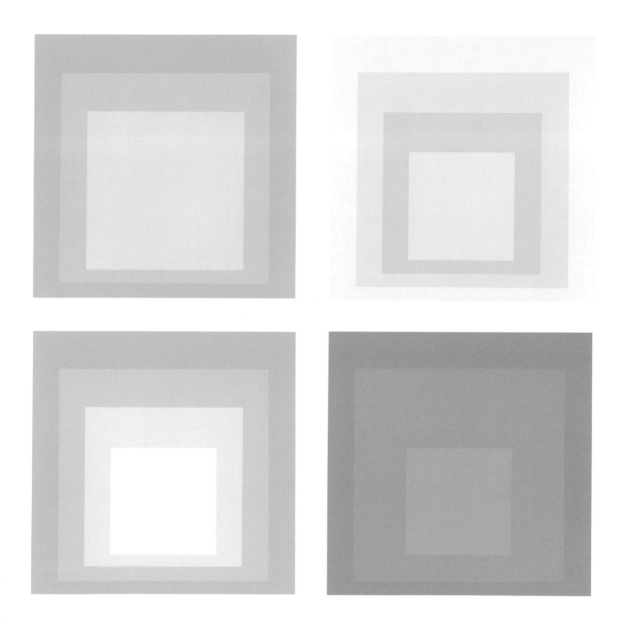

So many shades fill these sunny squares.
Does one remind you of a stick of butter? A school bus?
Mustard? A sunset? What else is yellow?

Colors can
CONTRAST

Colors contrast when they look like opposites. Wintery white meets bold black in these contrasting creations.

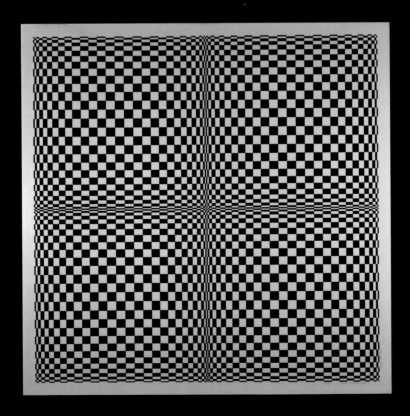

Compare big brushstrokes
with small squares
and curvy calligraphy
with long lines.
What other opposites
can you find?

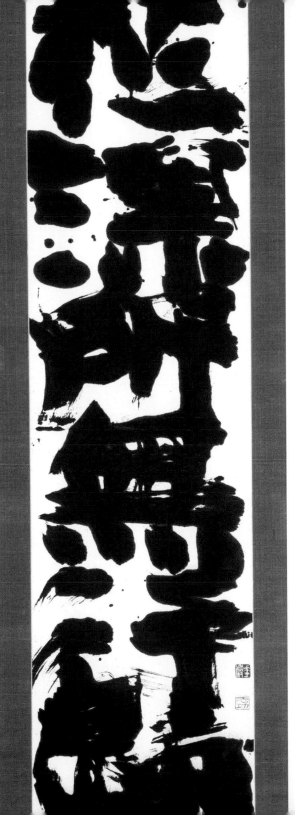

Colors can have many
NAMES

**The colors of these containers
were given fancy names:**

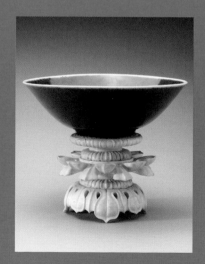

Oxblood

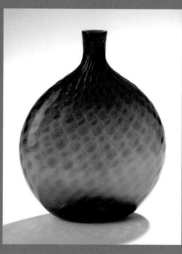

Amber

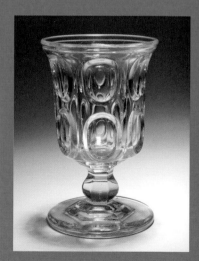

Canary

Come up with your own
creative color words.
Imagine you work for a crayon
or paint company and name
these colors something new.

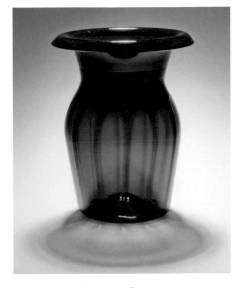

Amethyst

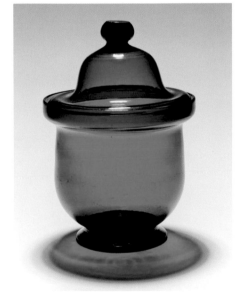

Emerald

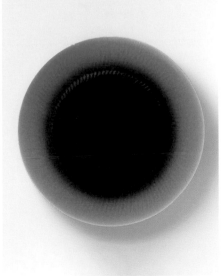

Cobalt

Colors can make
patterns

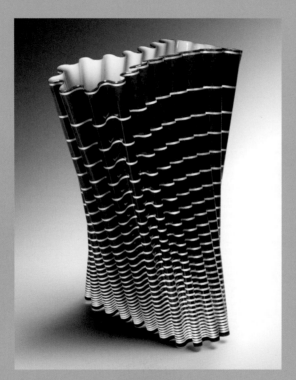

White, blue, white, blue, white, blue…
now you! What comes next? Colors or shapes
that repeat over and over make patterns.

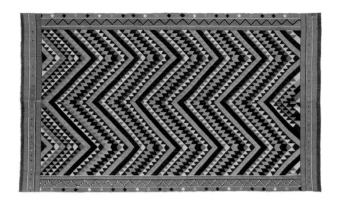

Lines and zigzags zoom through these whimsical works.
What other patterns are hiding?

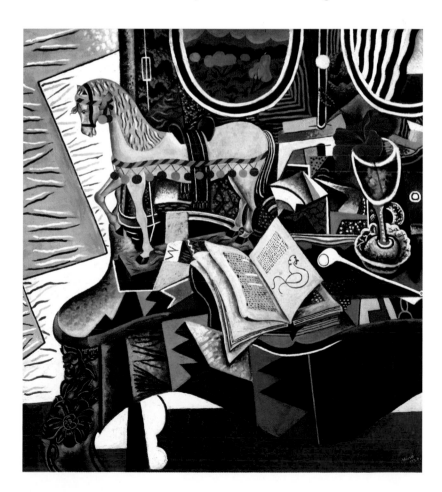

Colors can even make

MUSIC

**Patterns can create rhythms
that remind us of
sounds, songs, or beats.**

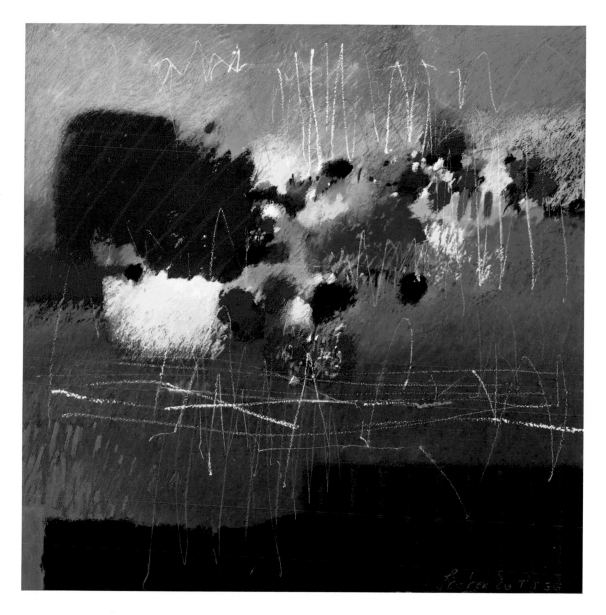

The jumpy sounds of jazz inspired this painting.
Which color looks loudest? Which is softest?
What color would a saxophone play? How about drums?

Colors can show
FEELINGS

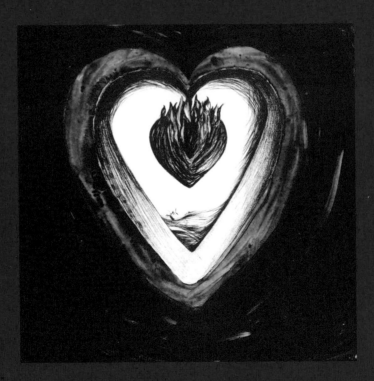

**Tickled pink, seeing red,
feeling blue, green with envy...the ways
we feel can be quite colorful.**

What feeling does each painting remind you of?
Surprised or silly? Loving or angry?
It could be two feelings at once.

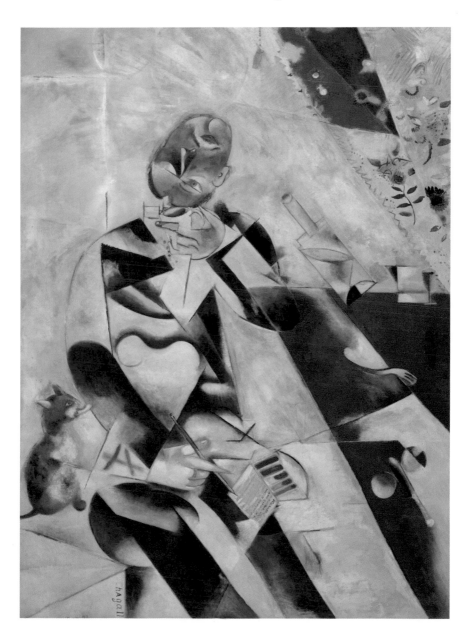

Colors can be
your favorite ♥

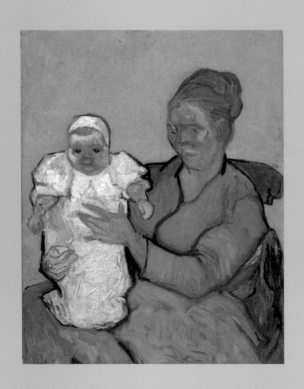
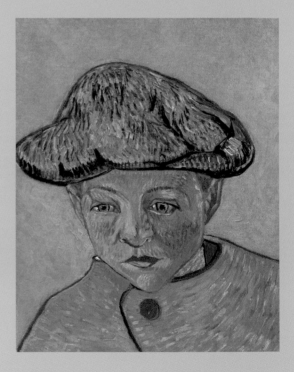

Do you have a favorite color?
What color do you think this artist liked best?

Vincent van Gogh loved sunshine, sunflowers,
and the color yellow. He even lived in a little yellow house.
The people in these paintings were his neighbors.

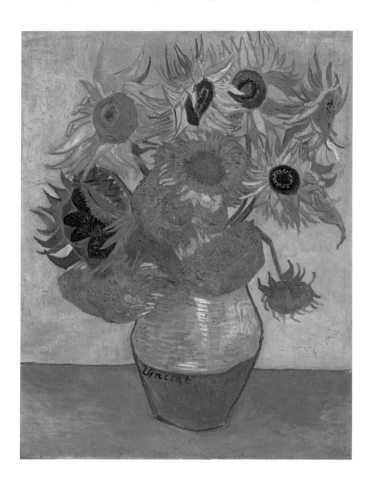

WHAT FILLS YOU
WITH COLOR?

GET COLORFUL!

How many ways can you experiment with color?
Here are some ideas to start you off.

COLOR COLLECTOR
Get ready to scavenge

Look around—how many things can you find that are red? Yellow? Purple? Gather up objects of all different colors to sort and arrange into a rainbow of treasures.

INSPIRATION: Check out this photograph in the museum's collection. It's of a child named Jimin surrounded by his many blue toys.

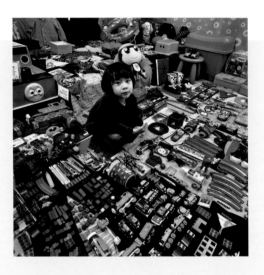

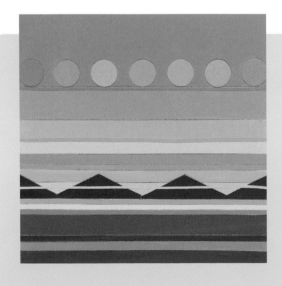

PICKY PALETTE
Get your art supplies

When an artist uses just a few colors, it's called a limited palette. Make a cool color creation with only shades of blue and purple. Now try reds, oranges, and yellows to make a warm wonder. Experiment with drawing materials, or cut colored paper to combine and collage.

INSPIRATION: A spectrum of colorful paper was sorted into cool and warm colors to create this collage.

CALMING CHROMA
Get comfy in a quiet corner

Close your eyes and calm your body. Imagine breathing in one color and breathing out another. Picture your belly filling up with different colors each time you take a breath, and watch the color change each time you blow out air.

INSPIRATION: Instead of using a brush, this artist poured paint down their colorful canvas. Try picturing paint falling each time you breathe out.

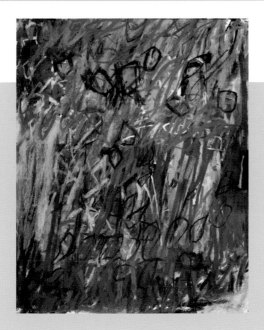

HIDDEN HUES
Get outside

Notice new colors on a nature walk. Blue skies, green grass, brown branches...but look closer! How many shades of green do you see on a tree? Are there colorful specks in that gray rock? How do cool shadows or warm spots of sun make colors change?

INSPIRATION: This artist spotted a simple green hedge in his friend's garden and drew it with countless colors.

"All colors are the friends of their neighbors and the lovers of their opposites."

—MARC CHAGALL

Warm

Cool

Primary

Secondary

Complementary

Author's Note

Ask children their favorite colors and they'll delight in answering, as though revealing a fundamental piece of themselves—which in many ways they are. Color plays a vital part in how we comprehend the world, from its basic symbolic functions (red means stop!) to its complex implications for personal identity. While working on this book, we found ourselves in a moment of cultural change that underscored color's capacity to conjure meaning. Rainbows appeared in windows as a sign of solidarity in a global pandemic, while Black Lives Matter protests led communities to confront the privilege and injustice inherent in skin color. The art in this book reminds us of the many possibilities of color, both as an optical tool and as a powerful way to communicate emotion, elicit empathy, and challenge perception. We hope this book promotes colorful conversations between young readers and their grown-ups and expands thinking about the many things colors can do.

Liz Yohlin Baill
COLLECTIONS INTERPRETER FOR YOUTH AND FAMILIES

Works Illustrated

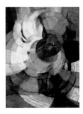

František Kupka (Czech, active in France, 1871–1957), *Disks of Newton (Study for "Fugue in Two Colors")*, 1912; oil on canvas; The Louise and Walter Arensberg Collection, 1950-134-122

Norton Bush (American, 1834–1894), *South American Sunset*, 1873; oil on canvas mounted on panel; Gift of the McNeil Americana Collection, 2016-76-1

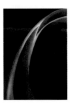

Georgia O'Keeffe (American, 1887–1986), *Red and Orange Streak*, 1919; oil on canvas; Bequest of Georgia O'Keeffe for the Alfred Stieglitz Collection, 1987-70-3

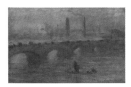

Claude Monet (French, 1840–1926), *Waterloo Bridge, Morning Fog*, 1901; oil on canvas; Bequest of Anne Thomson in memory of her father, Frank Thomson, and her mother, Mary Elizabeth Clarke Thomson, 1954-66-6

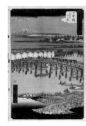

Utagawa Hiroshige I (Japanese, 1797–1858), *Nihonbashi: View of Eastern Clouds*, from the series *Famous Sights of the Fifty-Three Stations*, 1855; color woodcut; Bequest of Vivian Sharples Byrd, 1966-82-1(56)

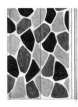

Jasper Johns (American, born 1930), *Nines*, 2006; encaustic and oil on canvas with string; Promised gift of Keith L. and Katherine Sachs, 139-2015-1

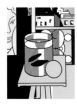

Roy Lichtenstein (American, 1923–1997), *Still Life with Goldfish*, 1974; oil and Magna on canvas; Purchased with the Edith H. Bell Fund, 1974-110-1

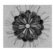 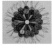 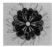

Marjorie Schick (American, 1941–2017), *Cezanne's Circles* (left) and *Monet's Circles* (center and right), from the series *Homage Circles*, 2011; painted canvas and wood with thread; Gift of the artist in honor of her family, courtesy Helen Drutt, 2016-135-5,4,6

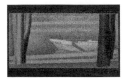

Georges Seurat (French, 1859–1891), *Moored Boats and Trees (Bateaux Amarrés et Arbres)*, 1890; oil on wood; Gift of Jacqueline Matisse Monnier in memory of Anne d'Harnoncourt, 2008-181-1

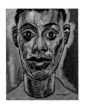

Beauford Delaney (American, active in Paris, 1901–1979), *Portrait of James Baldwin*, 1945; oil on canvas; 125th Anniversary Acquisition. Purchased with funds contributed by The Daniel W. Dietrich Foundation in memory of Joseph C. Bailey and with a grant from The Judith Rothschild Foundation, 1998-3-1

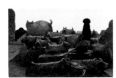

Peter Paone (American, born 1936), *Someone's Topiary*, 1978; color lithograph and screenprint; Print Club of Philadelphia Permanent Collection, 1979-64-5

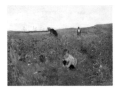

Victor Gabriel Gilbert (French, 1847–1935), formerly attributed to Mary Cassatt, *Poppies in a Field*, ca. 1880; oil on panel; Bequest of Charlotte Dorrance Wright, 1978-1-6

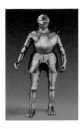

Field Armor, German, ca. 1500–10; iron alloy (steel), partially etched and engraved; copper alloy (brass); leather; Bequest of Carl Otto Kretzschmar von Kienbusch, 1977-167-4a–r

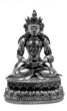

Amitayus, Bodhisattva of Endless Life, Tibetan, 14th–15th century; gilded copper alloy with turquoise and coral; Gift of Natacha Rambova, 1962-178-9

Josef Albers (American, born in Germany, 1888–1976), untitled screenprints from the portfolio *Formulation: Articulation, Volumes I and II* (New York: Harry N. Abrams; New Haven, CT: Ives-Sillman, 1972); color screenprints; Gift of the Josef Albers Foundation, 1975-51-50a, 20, 19b, 57a

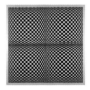

Edna Andrade (American, 1917–2008). *Color Motion,* 1965; screenprint; Print Club of Philadelphia Permanent Collection, 1966-81-4

Munakata Shikō (Japanese, 1903–1975), *No Footprints Show Where Flowers Are Deep,* 1959; ink on paper; mounted as a hanging scroll; Gift of Carl Zigrosser, 1974-179-5

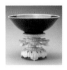

Oxblood Glazed Bowl, Chinese, 1662–1722; porcelain with copper-red glaze (*Langyao*); Gift of Major General and Mrs. William Crozier, 1944-20-50a,b

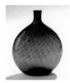

Flask, American, 1815–40; non-lead amber glass; The George H. Lorimer Collection, 1938-23-164

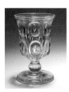

Spooner, American, 1850–60; pressed canary-yellow glass; Gift of Mrs. Richard W. Lloyd in honor of her father, Morgan Hebard, 1981-68-13

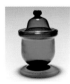

Sugar Bowl with Cover, American, 1790–1800; blown emerald-green glass; Gift of Mrs. W. Griffin Gribbel, 1947-26-1a,b

Kimura Yoshiro (Japanese, born 1946), *Vessel with Blue Glaze,* 2013; half-porcelain, cobalt blue glaze; Purchased with the East Asian Art Revolving Fund, 2018-37-1

Paneled Vase, American, 1820–30; blown molded amethyst glass; The George H. Lorimer Collection, 1953-29-82

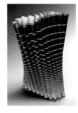

Naoki Takeyama (Japanese, born 1974), *Yumegatari (Reverie),* 2013; enameled copper, silver leaf (light blue with white interior); Purchased with funds contributed by Barbara B. and Theodore R. Aronson and Maxine and Howard Lewis, 2014-34-1.

Bagh Phulkari, possibly made in western Punjab, India, first half of 20th century; handspun cotton plain weave (*khaddar*) with silk embroidery in darning, pattern darning, and running, chain, and cross stitches; The Jill and Sheldon Bonovitz Phulkari Collection, 2017-9-12

Works Illustrated

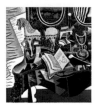

Joan Miró (Spanish, 1893–1983), *Horse, Pipe, and Red Flower*, 1920; oil on canvas; Gift of Mr. and Mrs. C. Earle Miller, 1986-97-1

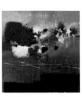

Moe Brooker (American, born 1940), *Present Futures*, 2006; mixed media and encaustic on wood panel; Purchased with funds contributed by Marion Boulton Stroud, 2006-149-1

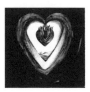

John E. Dowell Jr. (American, born 1941), *Untitled (Burning Orange and Red Heart)*, 1993; color lithograph; Purchased with the Julius Bloch Memorial Fund created by Benjamin D. Bernstein, 1994-67-1

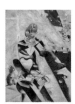

Marc Chagall (French, born in Russia, 1887–1985), *Half-Past Three (The Poet)*, 1911; oil on canvas; The Louise and Walter Arensberg Collection, 1950-134-36

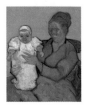

Vincent van Gogh (Dutch, 1853–1890), *Portrait of Madame Augustine Roulin and Baby Marcelle*, 1888; oil on canvas; Bequest of Lisa Norris Elkins, 1950-92-22)

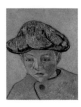

Vincent van Gogh, *Portrait of Camille Roulin*, 1888; oil on canvas; Gift of Mr. and Mrs. Rodolphe Meyer de Schauensee, 1973-129-1

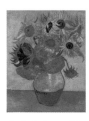

Vincent van Gogh, *Sunflowers*, 1889; oil on canvas; The Mr. and Mrs. Carroll S. Tyson, Jr. Collection, 1963-116-19

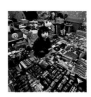

JeongMee Yoon (Korean, born 1969), *Jimin and His Blue Things*, from the series *The Pink and Blue Project*, 2007; printed 2008; chromogenic print; Gift of the Young Friends of the Philadelphia Museum of Art, 2008-108-1

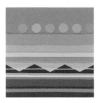

Edna Andrade (American, 1917–2008), *Straight Road*, 1982; collage of cut colored papers on paper; Gift of Ann and Donald W. McPhail, 2016-218-1

Morris Louis (American, 1912–1962), *Delta*, 1960; acrylic resin on canvas; Centennial gift of the Woodward Foundation, 1975-81-9

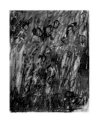

Bill Scott (American, born 1956), *Hedge II*, 1987; pastel over lithograph on paper; Purchased with the Julius Bloch Memorial Fund created by Benjamin D. Bernstein, 1989-14-1

Acknowledgments

My sincere gratitude to the many friends and colleagues who contributed to this book. I am endlessly grateful to Katie Reilly for championing the museum's children's publication program and to her talented team, including Rich Bonk, Sydney Holt, and Mary Cason, as well as to David Updike for his thoughtful honing of this content. I am so appreciative of Marla Shoemaker, Emily Schreiner, Damon Reaves, and Jenni Drozdek for their support and advocacy during the many stages of this publication's development. Our thanks to Princeton Architectural Press, especially Lynn Grady, Rob Shaeffer, Natalie Snodgrass, Sara Stemen, Paul Wagner, and Lia Hunt for bringing *What Can Colors Do?* to fruition. A final thank-you to Logan, Luca, and Andrew for filling each day with chaos, creativity, and color.

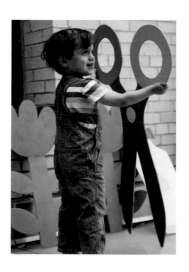 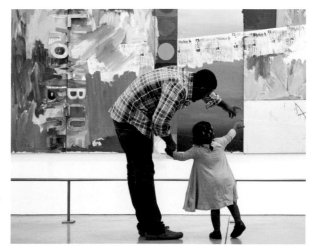

PUBLISHED BY
Princeton Architectural Press
202 Warren Street
Hudson, New York 12534
www.papress.com

WITH

Philadelphia Museum of Art
2525 Pennsylvania Avenue
Philadelphia, PA 19130-2440
www.philamuseum.org

This publication was made possible by a grant
from The Women's Committee of the Philadelphia
Museum of Art.

FOR PRINCETON ARCHITECTURAL PRESS
Editors: Rob Shaeffer and Sara Stemen
Designers: Natalie Snodgrass and Paul Wagner

FOR THE PHILADELPHIA MUSEUM OF ART
The William T. Ranney Director of Publishing:
Katie Reilly
Editors: David Updike and Mary Cason

Library of Congress Cataloging-in-Publication Data
NAMES: Yohlin Baill, Liz, author.
TITLE: What can colors do? / Liz Yohlin Baill.
DESCRIPTION: New York : Princeton Architectural Press ;
 Philadelphia, PA : Philadelphia Museum of Art, [2021] |
 Audience: Ages 4–8 | Audience: Grades K-1 |
SUMMARY: "More than twenty works of art from the
 Philadelphia Museum of Art's collection introduce
 children to concepts about color"— Provided by
 publisher.
IDENTIFIERS: LCCN 2020025847 | ISBN 9781616899660
 (hardcover)
SUBJECTS: LCSH: Color in art—Juvenile literature. |
 Philadelphia Museum of Art—Juvenile literature.
CLASSIFICATION: LCC N7432.7 .Y64 2021 | DDC 701/
 .85—dc23 LC record available at https://
 lccn.loc.gov/2020025847